G000125008

Texting Syria

Liam Maloney

Dazibao

black dog
publishing
london uk

ل: واخي اي تلمكان المكان يل بيساع 10 بيساع 15

ل: وهوخلي يدير بالو كمان، حاجتو حصار

س: اي انشالله لنشوف بس عم يظبطو دفاتر العايلة من شان الاطفال

And yes brother, the place
that fits 10 can fit 15
And tell him to take care.
That's enough siege for him

Yes insh'allah, let's see.
They're just fixing the family
documents for the children

Et oui mon frère, si on
tient à 10, on tient à 15
Et dis-lui de prendre soin de lui.
Assez de combat pour lui

Oui insh'allah, on va voir.
Ils règlent les documents
familiaux pour les enfants

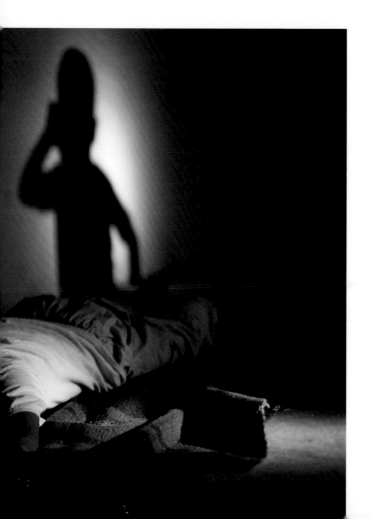

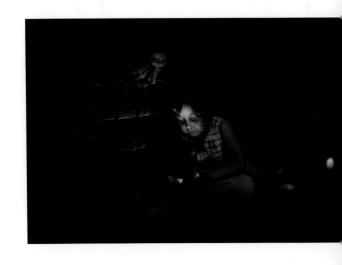

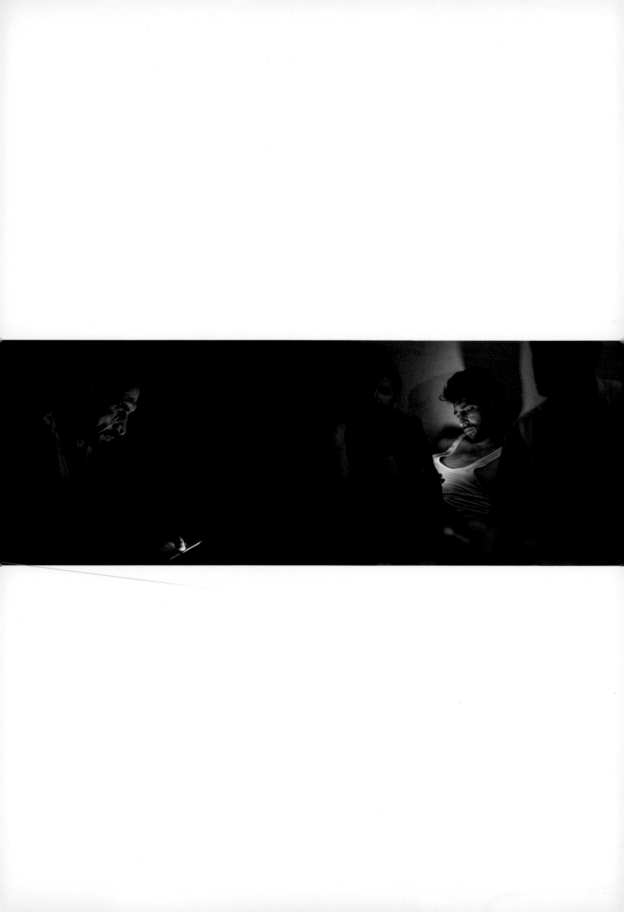

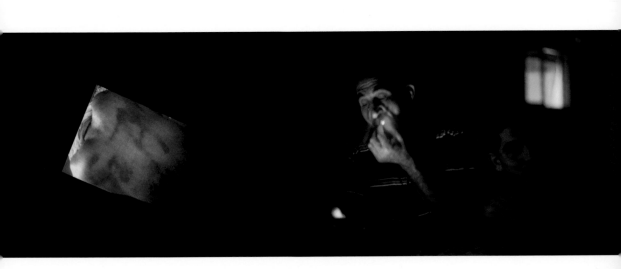

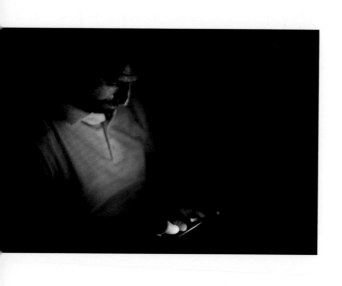

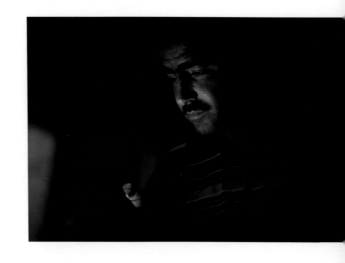

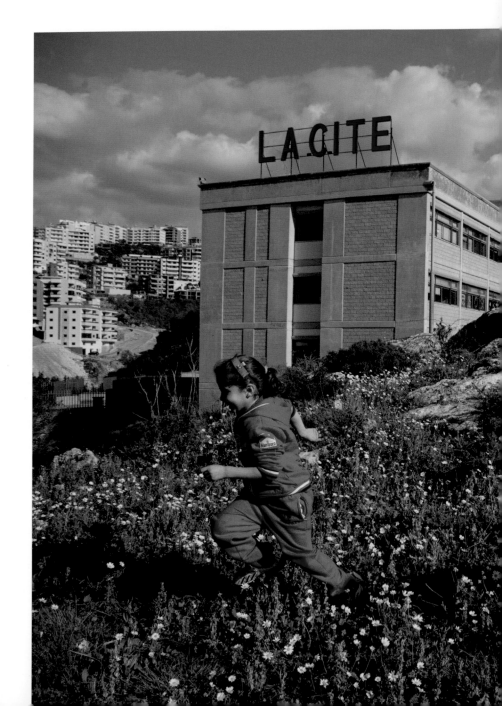

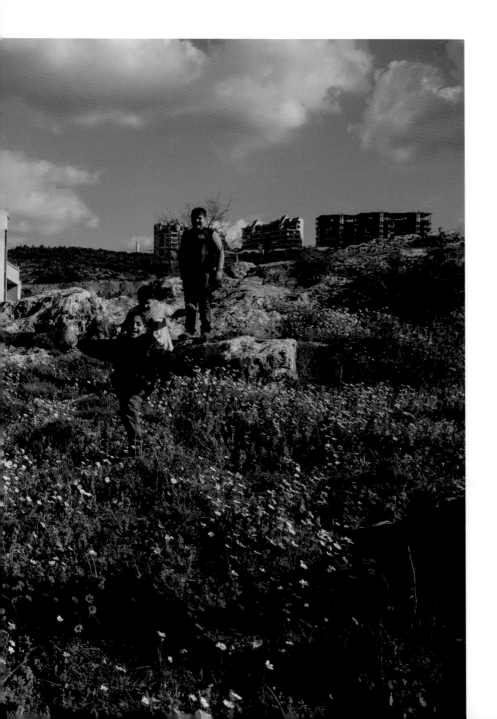

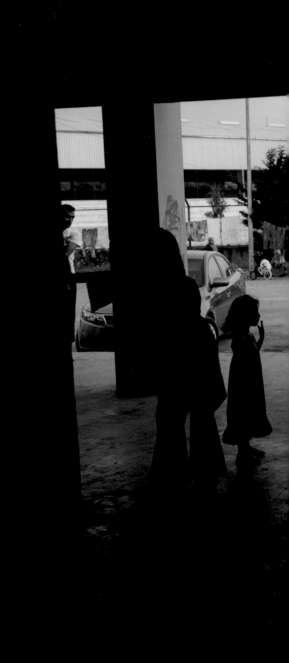

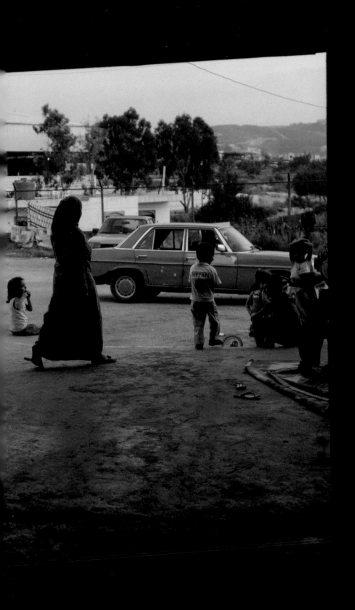

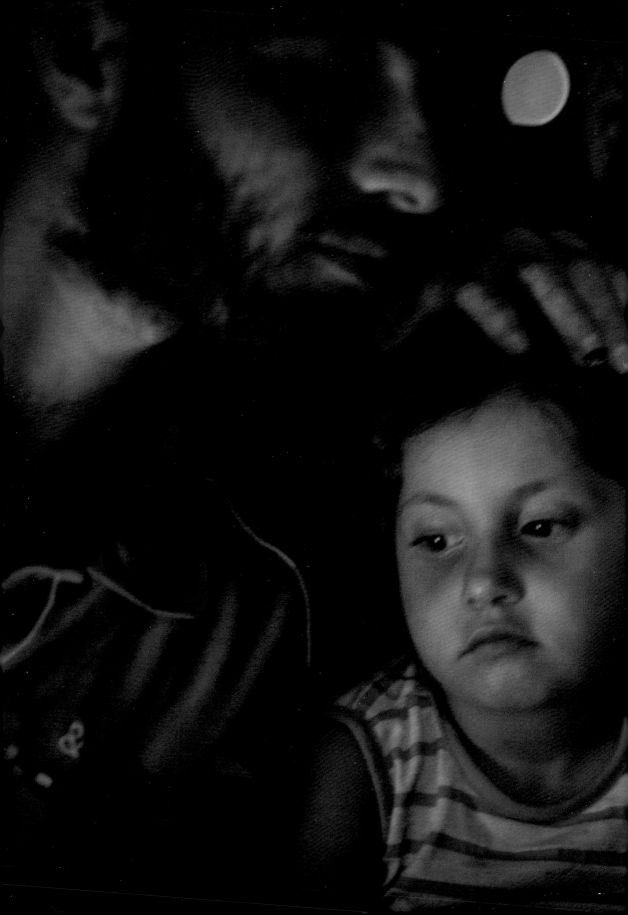

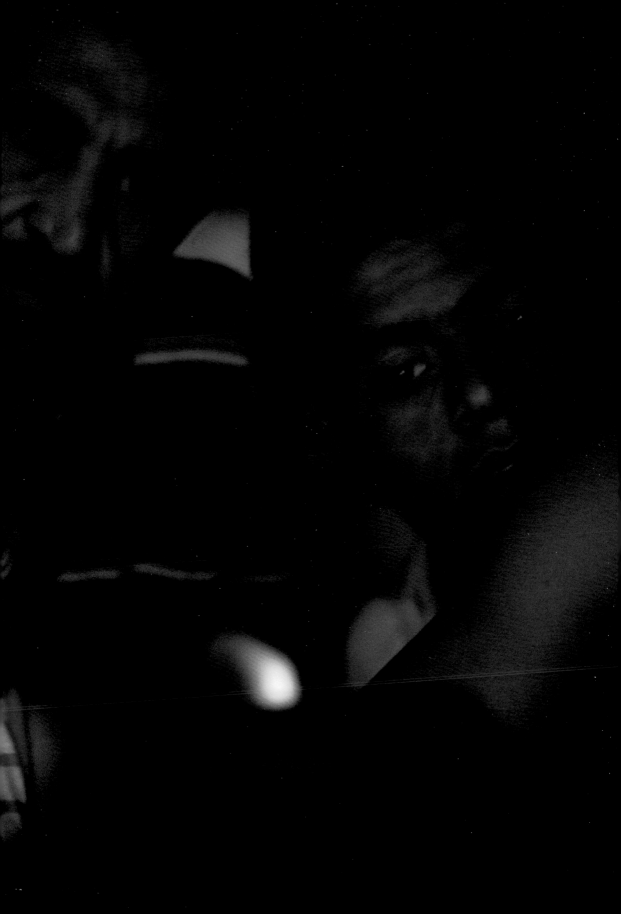

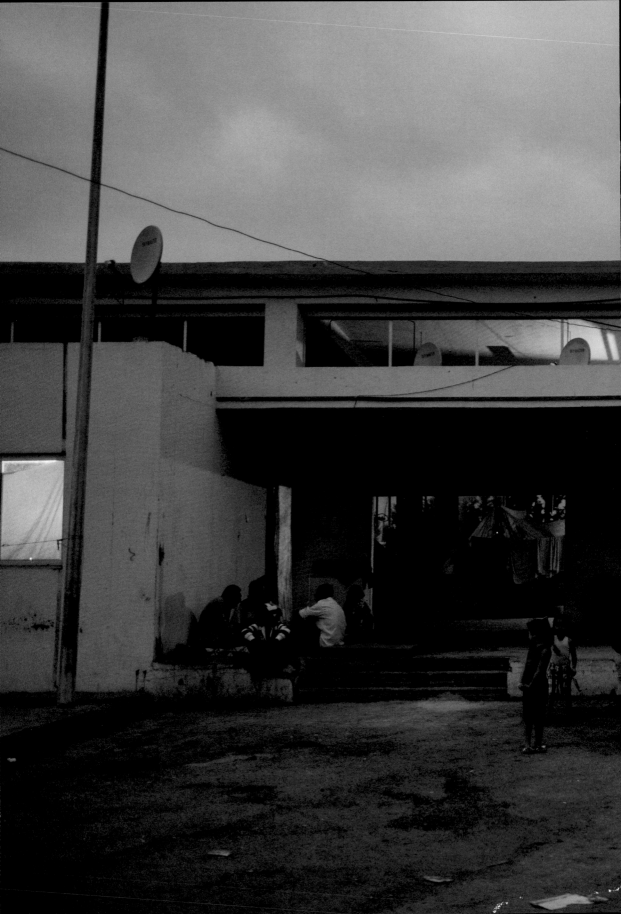

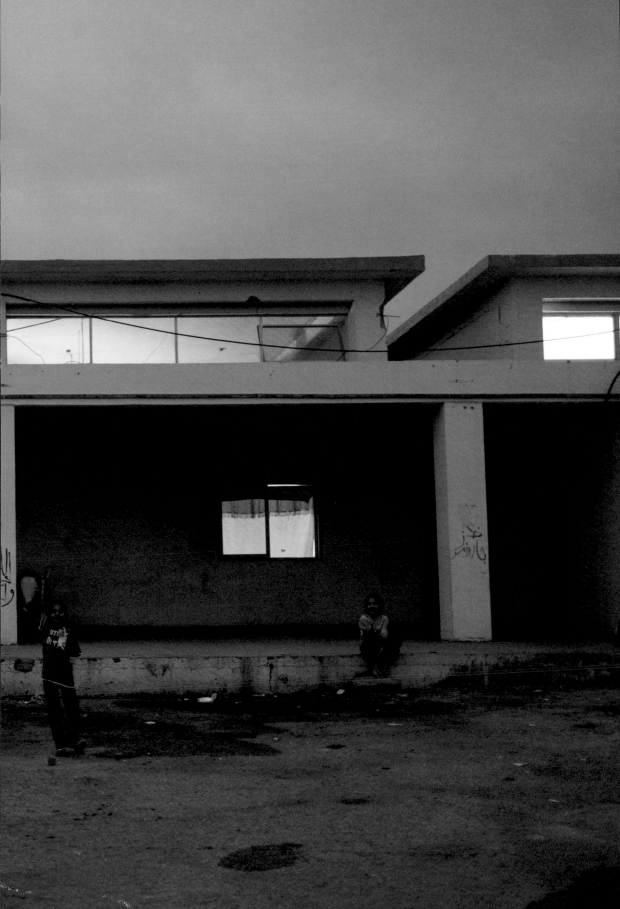

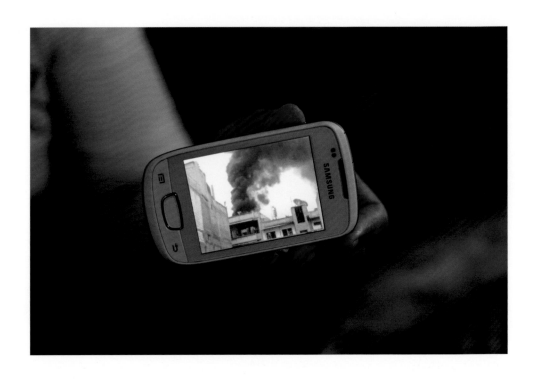

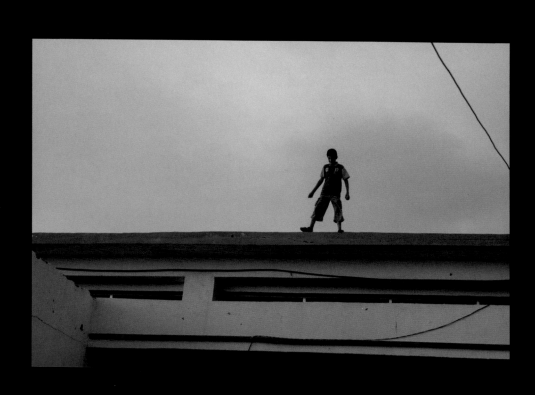

C'est ok, on est
assiégés mais on
peut avoir du pain

Ok super
Mais écoute,
si tu veux venir au Liban...
Et si tu veux je peux parler
à mon cousin à Faqra,
si tu as peur
Dieu nous aidera

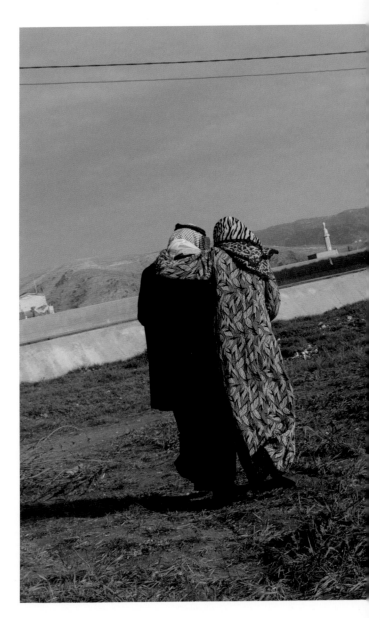

سن ماشي الحال حصار بس عم
يفوتو خبز

ل: اي تمام

ل: بس وينك

ل: اذا بدكم تطلعوا علبنان

ل: وانا اذا بدكن بحكي مع ابن خالتي بفقرا ، اذا خايفين

ل: وبيفرجها الله

It's ok. We're under siege but
they are able to bring in bread

Ok great
But listen
if you want to come to Lebanon...
And if you want I can speak with
my cousin in Faqra, if you're scared
God will help us

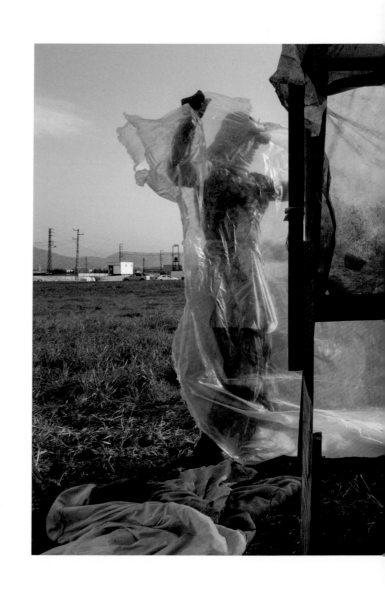

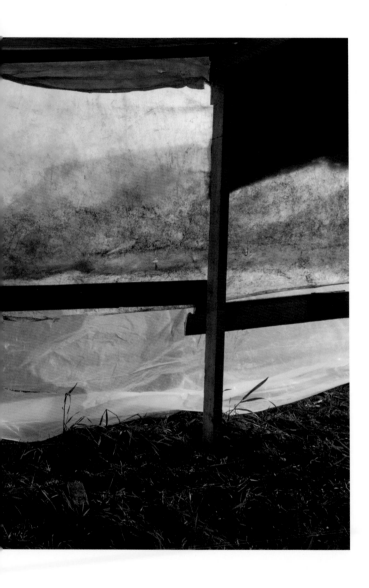

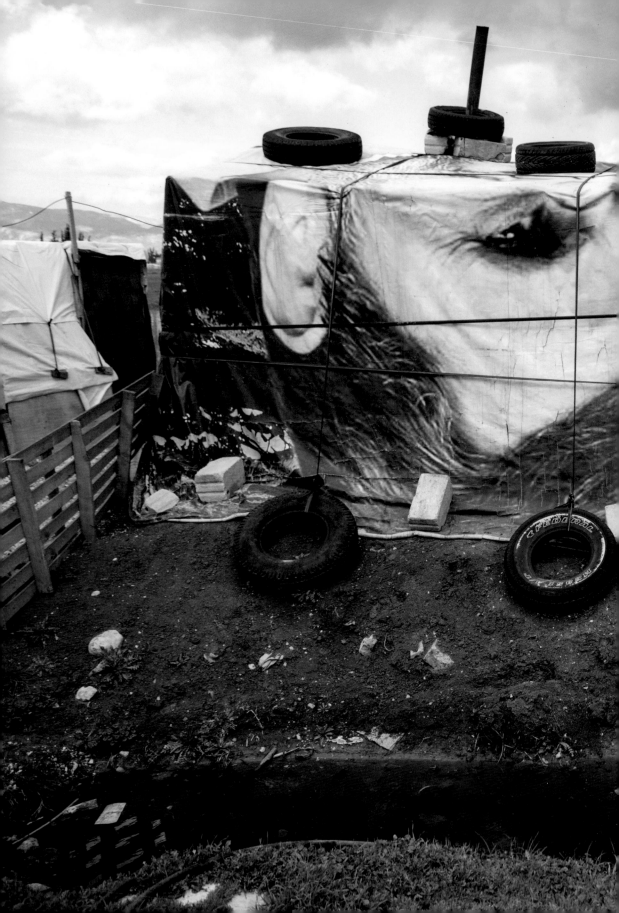

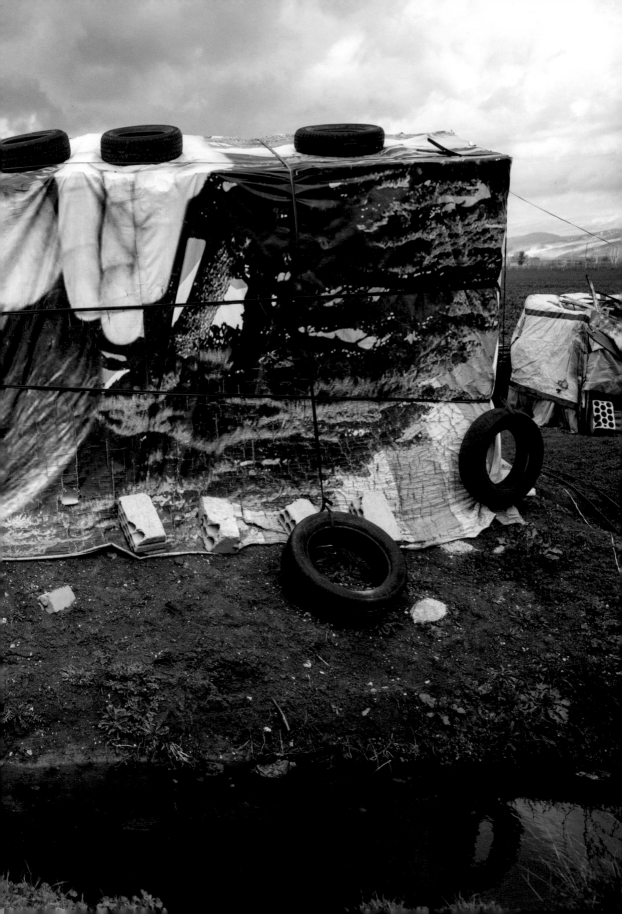

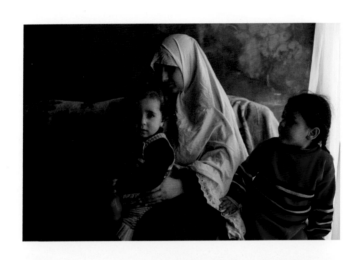

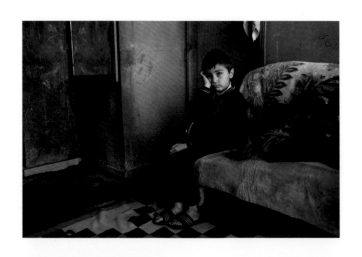

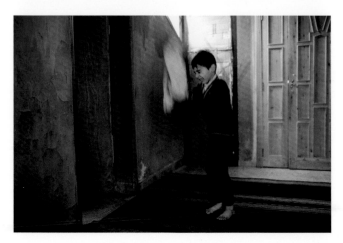

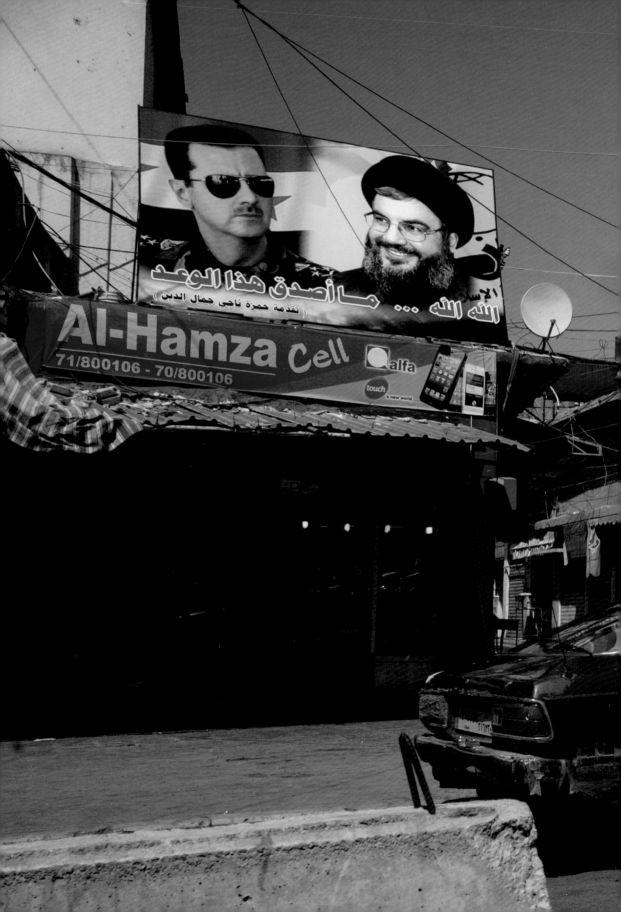

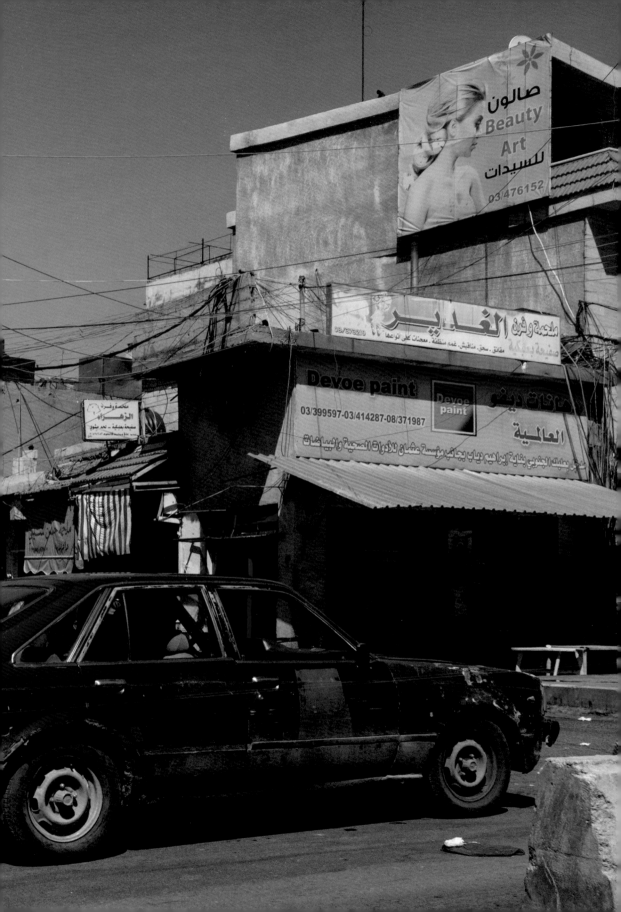

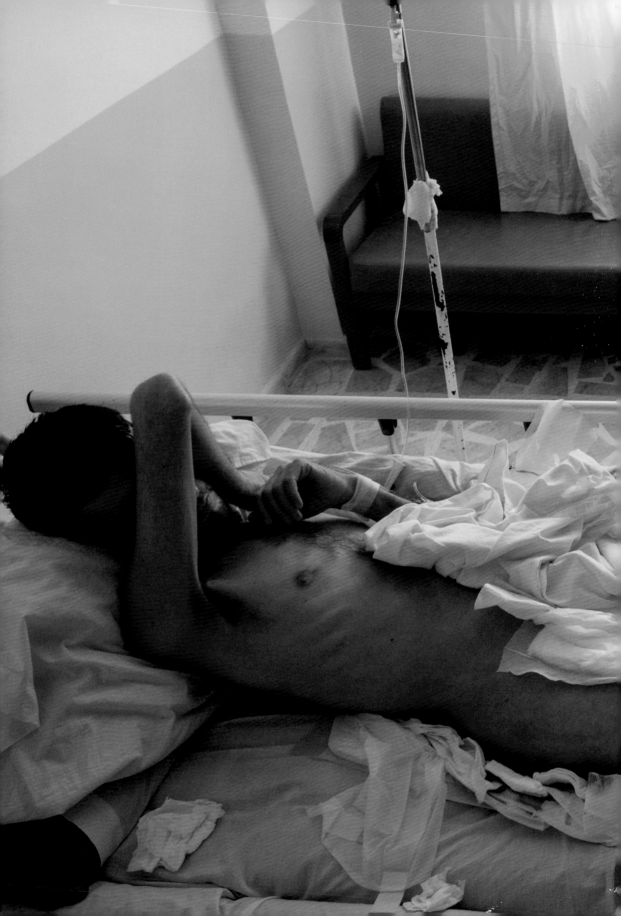

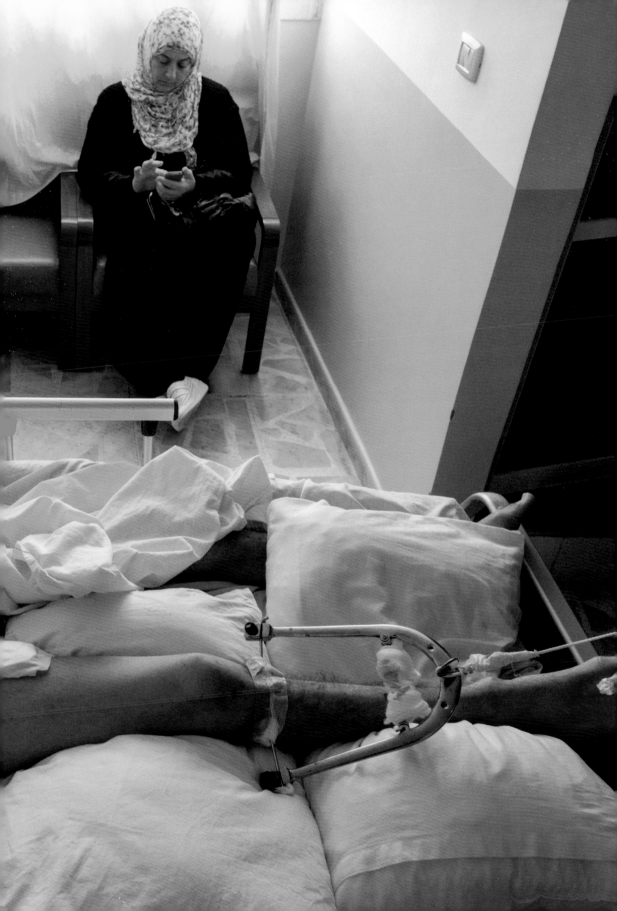

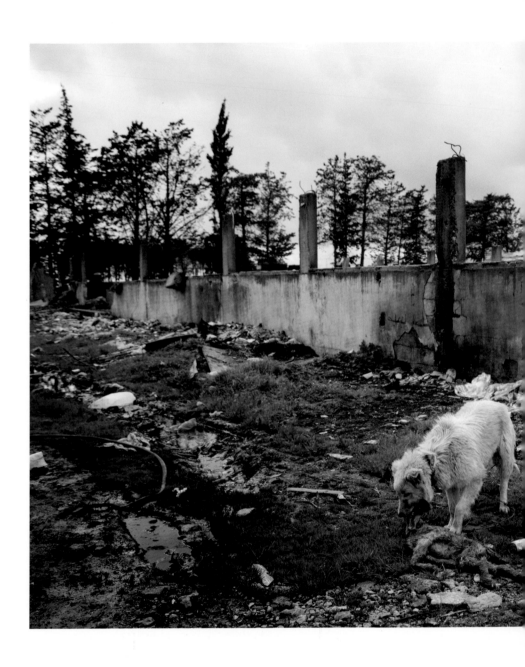

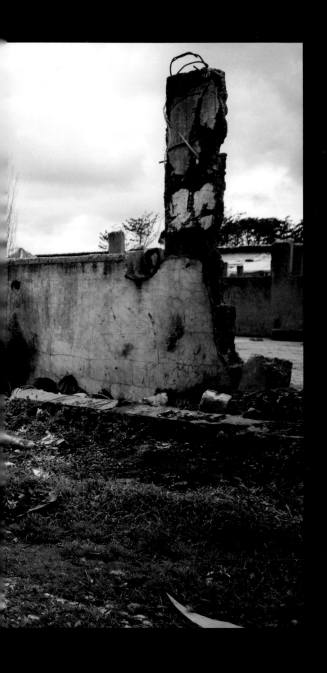

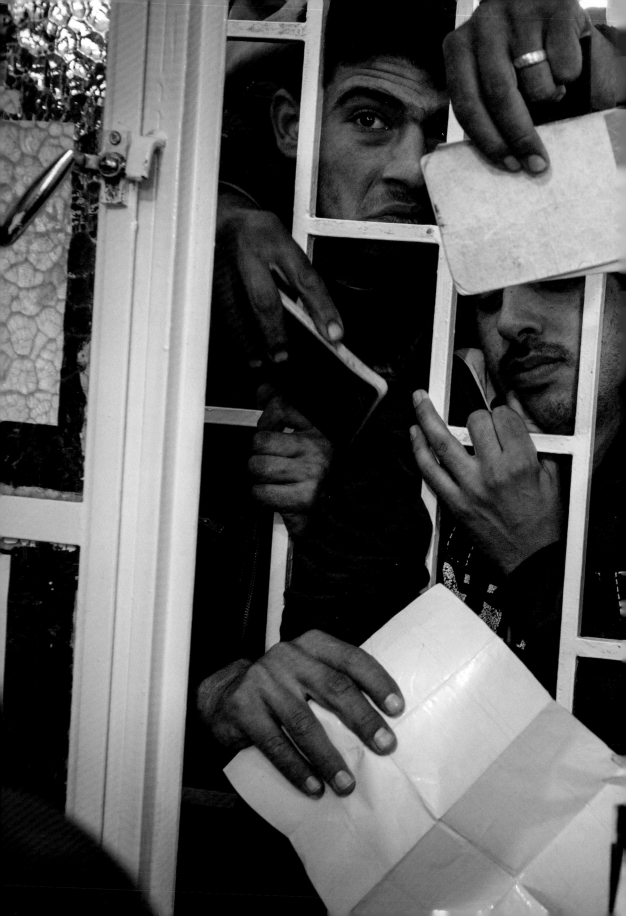

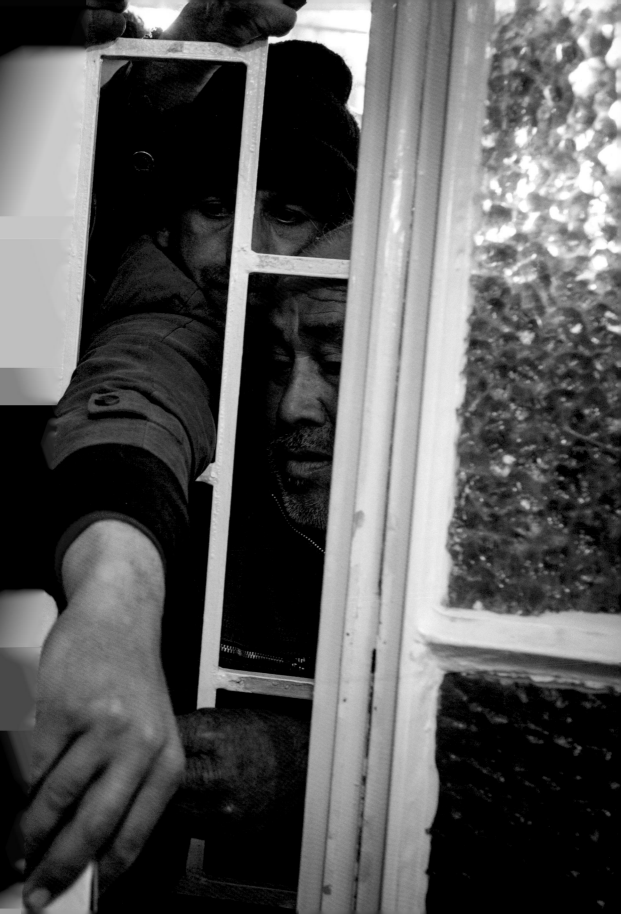

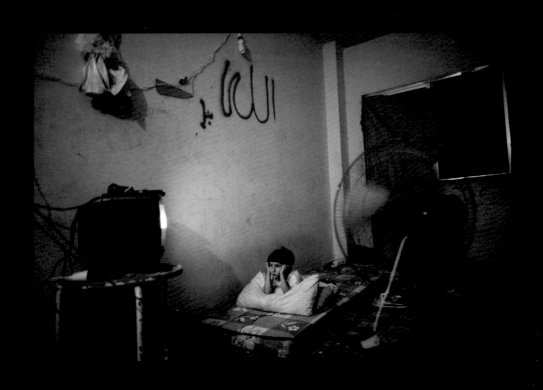

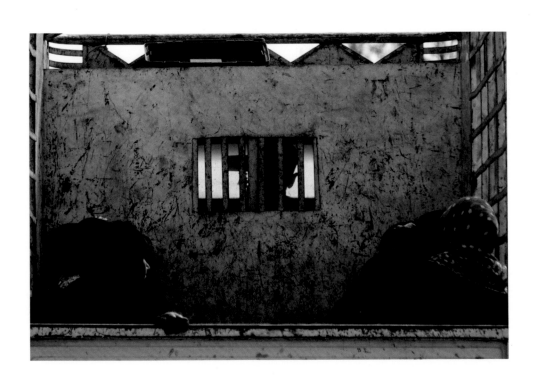

And are you retaliating?
Against the bombing?
Where are you now?

And my sisters?

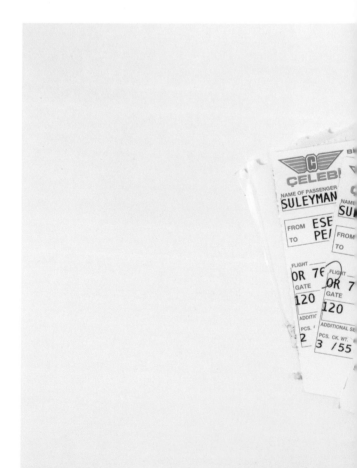

Et vous ripostez ?
Contre les bombardements ?
Où es-tu maintenant ?

Et mes sœurs ?

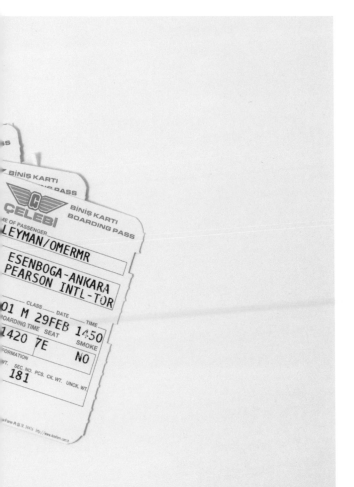

ل: شو انتو عم تردوا؟

ل: عالضرب؟

ل: وهلق انت وين واخواتي؟

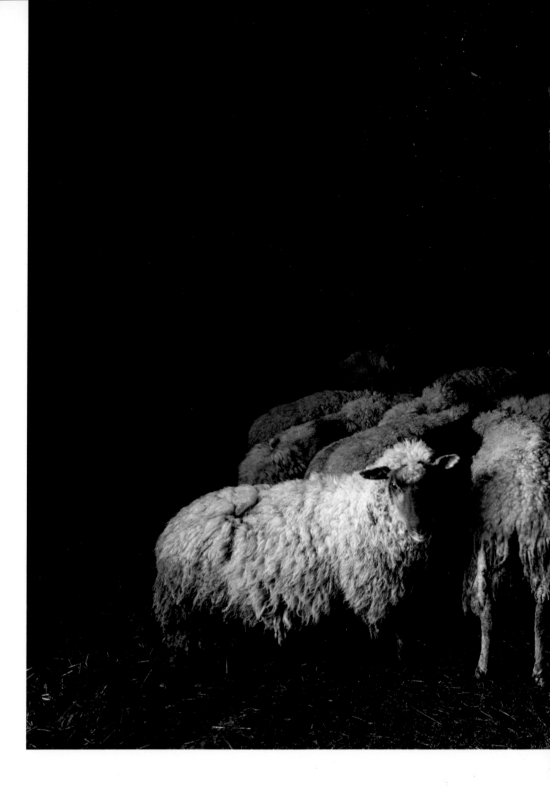

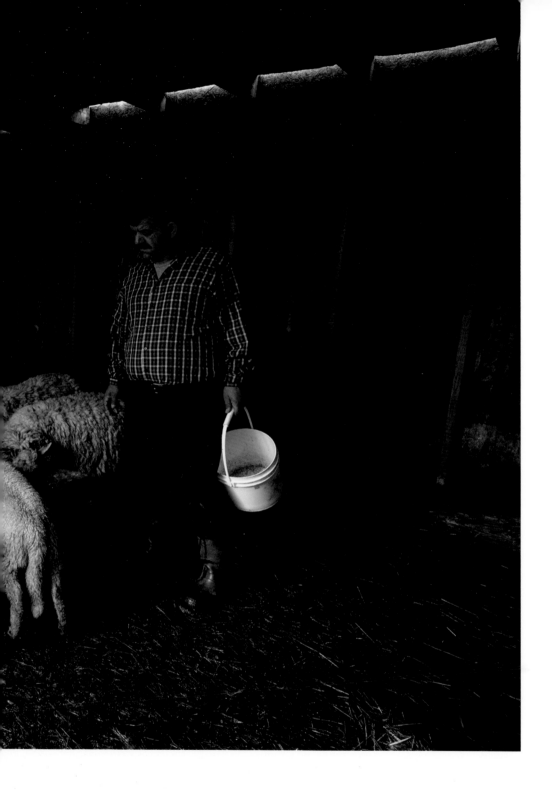

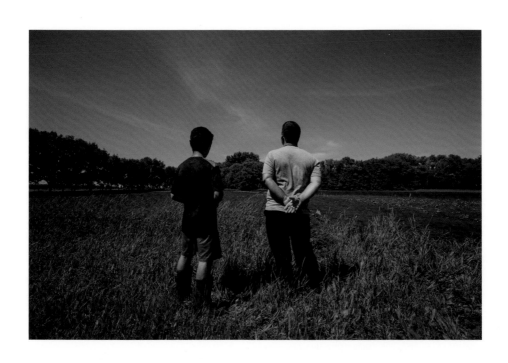

Ali School

one time, when I travelled to Canada
and I start with new school.
when I went first time to the school,
I was very excited to start, But I saw
every thing deffrent. I start with Grade "8"
and I didn't Know english befor. So this
thing was very bad thing. Because when
they speaking, I cant understand what
they say. But the teachers was good
when I go to the class they help me
and didn't gave me any thing hard to
study, I was didn't speak with any student
because I don't know what they will say.
I thinked they will be funny. When I amspeak,
Everything was very hard. But more time
more easy for me and more friends. when
I start speak slowly enghish I had more
friends and can understand to the teacher.
Now love canada and the school becaus
I saw everyone good they like the
help the people and I think everyone
liked me. Now I like the school
and my friends and the teachers and
everyone helped me. I say now very goo
school.

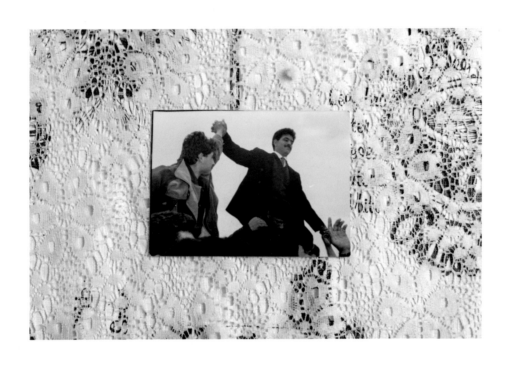

Hello
What news of the village?

 Yes now things are good.
 The bombing has stopped.
 I am on Kherbe Road

May God protect you

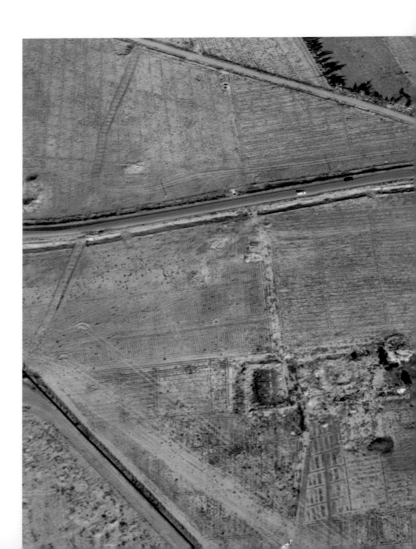

ل: الو
شو أخبار الضيعة

س: اي هلق الوضع تمام وقف الضرب أنا على طريق الخربة

ل: الله يحميك

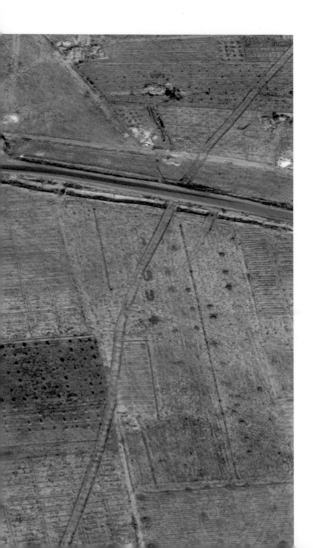

Salut
Quelles sont les nouvelles
du village ?

Oui maintenant
tout va bien,
les bombardements
sont finis je suis sur
la route Kherbe

Dieu te protège

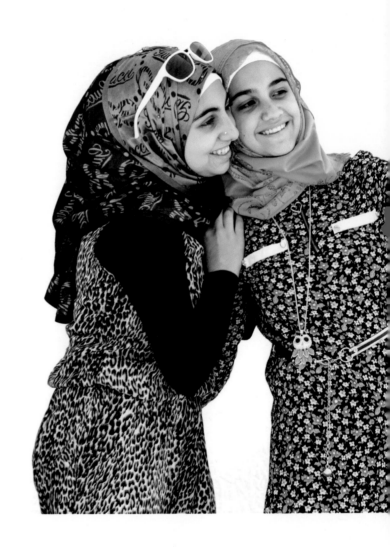

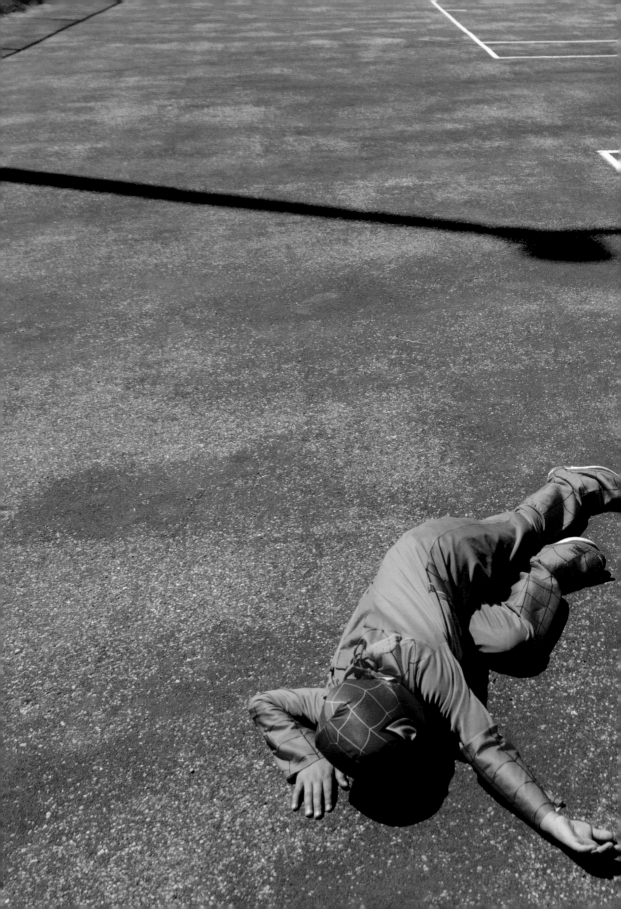

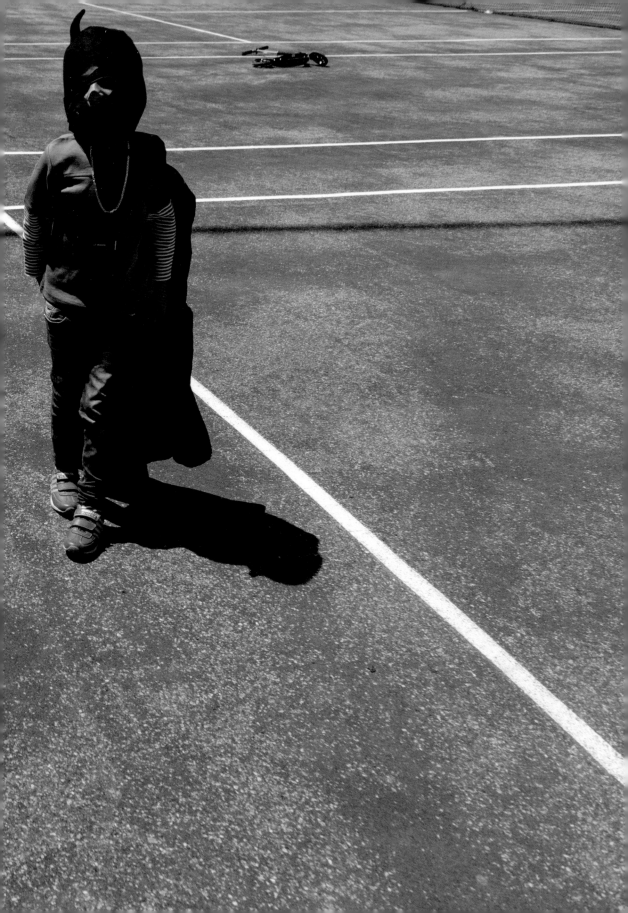

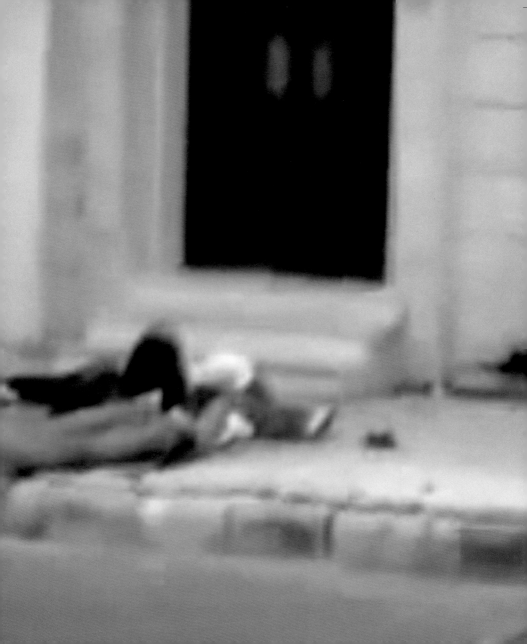

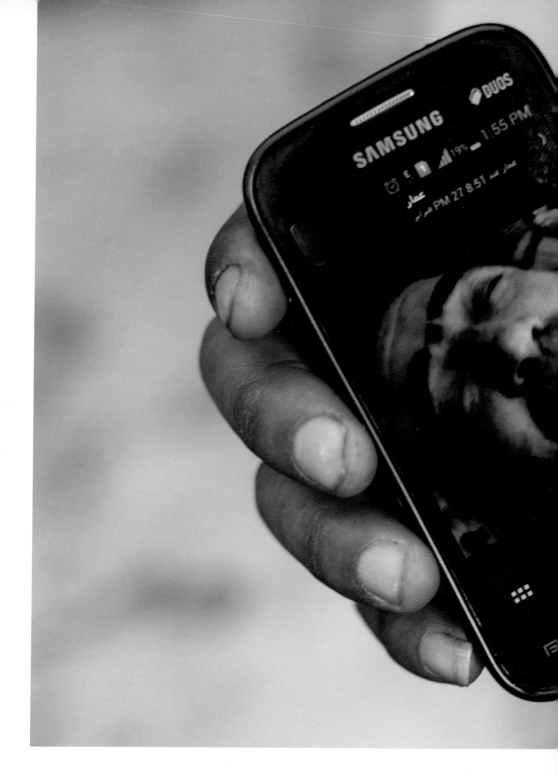

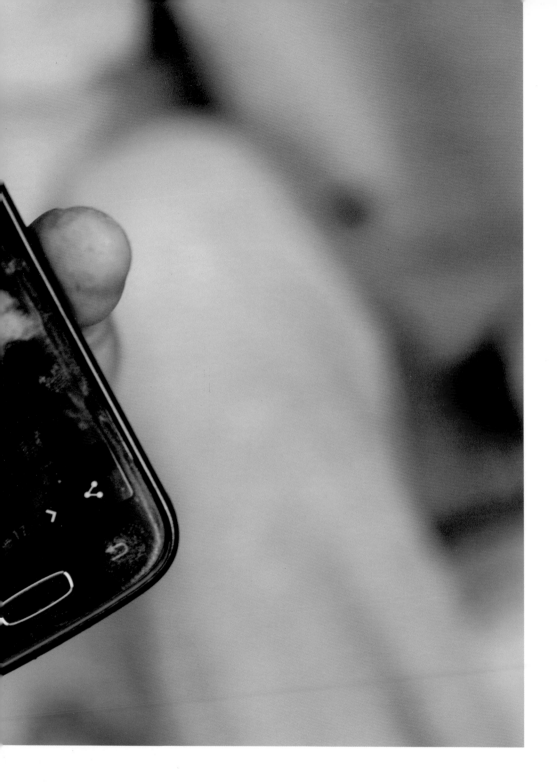

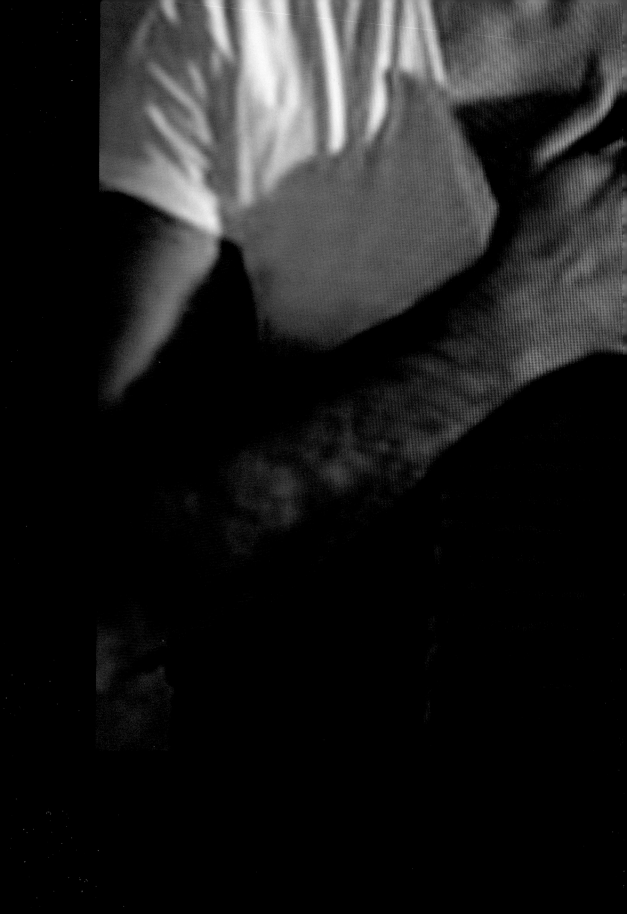

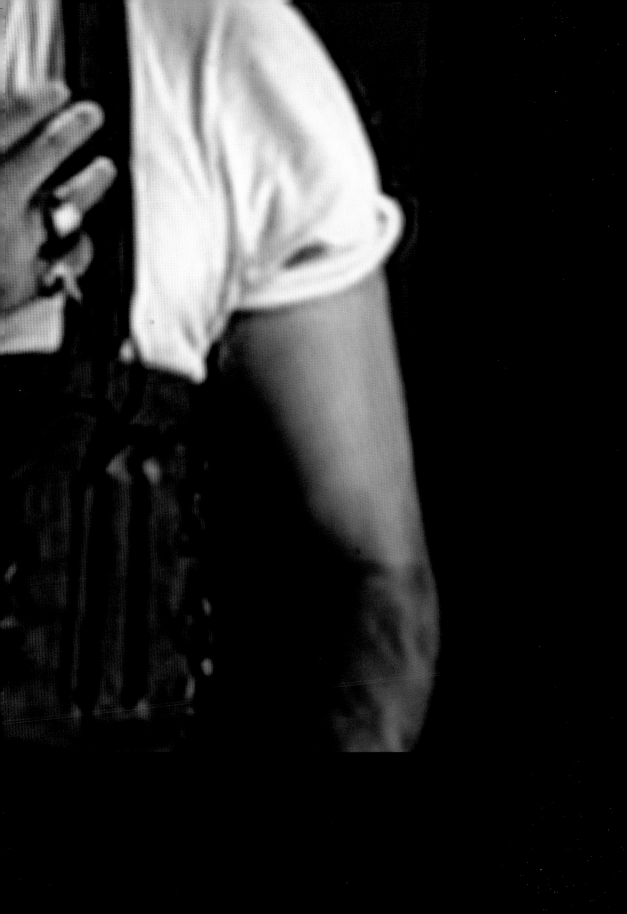

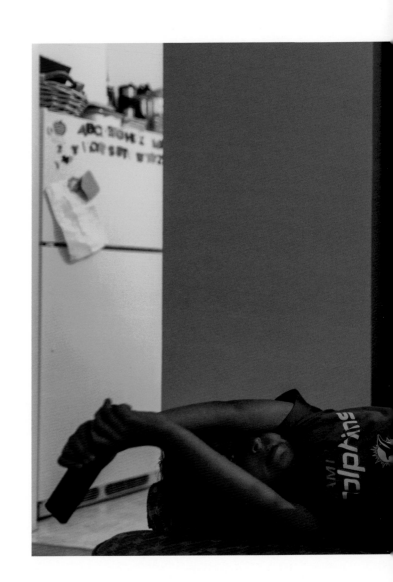

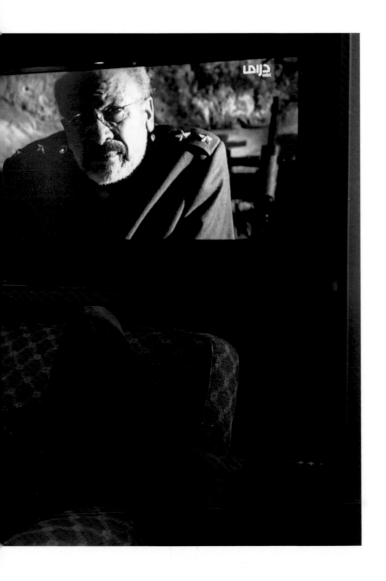

Exclusivement consacré à l'œuvre d'un artiste, chaque titre de la collection *Les portables* est une exposition itinérante sans circulation prédéterminée et surtout sans limite de points de chute.

Dedicated exclusively to the work of one artist, each title of the series *Les portables* is a travelling exhibition with unlimited venues and circulation.

AUTRES TITRES DE LA COLLECTION
OTHER TITLES IN THE SERIES

Performing an Archive –Suzy Lake
O/ Divided/Defined, Weights, Measures, and Emotional Geometry –Jim Verburg
Seafaring and Disenchanted Matters –Zineb Sedira
Emergency Weather –Ulrika Ferm
Risk Colour Book –Gustavo Artigas
9 1/2 x 6 3/4 –Manon Labrecque
Private Property / Propriété privée –Thomas Kneubühler

Liam Maloney

Né à Montréal, Liam Maloney est photographe documentaire, artiste et réalisateur. Son travail se penche sur les migrations forcées et la rencontre troublante entre technologie et intimité en temps de guerre. Ses photographies ont été publiées dans de nombreuses revues parmi lesquelles le *TIME*, *The Guardian*, *Foreign Policy*, *Mother Jones*, *The Globe and Mail*, *Maclean's* et *Vice Magazine*.

L'installation *Texting Syria*, à partir de laquelle cette publication est élaborée, a été largement diffusée, notamment dans le cadre de *Moving Walls*, une exposition annuelle de photographies documentaires produite par le Open Society Foundations Documentary Photography Project (2015–2016), le Mois de la Photo à Montréal (2015), le Harbourfront Centre (2015), le Festival Images Vevey (2014) et le Nobel Peace Center dans le cadre de l'exposition *Detours* (2017). Il a récemment participé à l'exposition collective *Insecurities: Tracing Displacement and Shelter* au MoMA (2016–2017).

Born in Montreal, Liam Maloney is a documentary photographer, artist and filmmaker. His work examines forced migrations and the disruptive intersections of technology and intimacy during wartime. His photographs have been published in numerous magazines including *TIME*, *The Guardian*, *Foreign Policy*, *Mother Jones*, *The Globe and Mail*, *Maclean's*, *Vice Magazine* and many others.

The installation *Texting Syria*, from which this publication is developed, has been widely shown, including in *Moving Walls*, an annual documentary photography exhibition produced by the Open Society Foundations Documentary Photography Project (2015–2016), the Mois de la Photo à Montréal (2015), the Harbourfront Centre (2015), Festival Images Vevey (2014) and at the Nobel Peace Center as part of the exhibition *Detours* (2017). He recently participated in the MoMA's group exhibition *Insecurities: Tracing Displacement and Shelter* (2016–2017).

Images clés / Key images.

Sous la direction de | Editor
France Choinière

Assistée de | Assisted by
Jennifer Pham

Conception graphique | Design
Studio TagTeam

Black Dog Publishing Limited
308 Essex Road, London
N1 3AX United Kingdom
t. +44 (0)207 713 5097
f. +44 (0)207 713 8682
info@blackdogonline.com
www.blackdogonline.com

Dazibao
5455, avenue de Gaspé, espace 109,
Montréal, Québec, Canada, H2T 3B3
t. + (514) 845-0063
info@dazibao.art
www.dazibao.art

Dazibao bénéficie du soutien financier du Conseil des arts
et des lettres du Québec, du Conseil des arts du Canada, du
Conseil des arts de Montréal et du Ministère de la Culture et
des Communications. / Dazibao is supported by the Conseil
des arts et des lettres du Québec, the Canada Council for the
Arts, the Conseil des arts de Montréal and the Ministère de
la Culture et des Communications.

Les opinions exprimées dans cette publication sont celles de
l'auteur et ne reflètent pas celles des éditeurs. / All opinions
expressed within this publication are those of the author and
not necessarily of the publishers.

Black Dog Publishing est une compagnie écoresponsable.
Texting Syria est imprimé sur du papier de sources durables.
Texting Syria est coédité par Black Dog Publishing et
Dazibao. / Black Dog Publishing is an environmentally
responsible company. Texting Syria is printed on sustainably
sourced paper. Texting Syria is published in collaboration
by Black Dog Publishing and Dazibao.

Dépôt legal | Legal deposit
3ᵉ trimestre 2017 | 3ʳᵈ Quarter 2017
Bibliothèque et Archives nationales du Québec – Bibliothèque
et Archives Canada | Library and Archives Canada

Achevé d'imprimer en xxx par | Printed in xxx by
Black Dog Publishing

Catalogage avant publication de la British Library. Des notices CIP
sont disponibles pour ce livre depuis la British Library. / British
Library Cataloguing-in-Publication Data. A CIP record for this book
is available from the British Library.

**Catalogage avant publication de Bibliothèque et Archives
nationales du Québec et Bibliothèque et Archives Canada**

Maloney, Liam, 1975-

 Photographies. Extraits]

 Texting Syria

 (Les portables)
 Publié en collaboration avec Black Dog Publishing.
 Texte en français et en anglais.

 ISBN 978-2-922135-47-3
 (couverture rigide : Dazibao)
 ISBN 978-1-911164-88-3
 (couverture rigide : Black Dog Publishing)

 1. Maloney, Liam, 1975- .
 2. Photographie artistique.
 3. Syrie - Ouvrages illustrés.
 I. Titre. II. Collection : Portables.

 TR647.M34 2018 779.092 C2017-941001-6F

**Bibliothèque et Archives nationales du Québec and Library
and Archives Canada cataloguing in publication**

Maloney, Liam, 1975-

 [Photographs. Selections]

 Texting Syria

 (Les portables)
 Co-published by Black Dog Publishing.
 Text in English and French.

 ISBN 978-2-922135-47-3 (hardcover : Dazibao)
 ISBN 978-1-911164-88-3
 (hardcover : Black Dog Publishing)

 1. Maloney, Liam, 1975- .
 2. Photography, Artistic.
 3. Syria - Pictural works.
 I. Title. II. Series : Portables.

 TR647.M34 2018 779.092 C2017-941001-6E

art design fashion
history photography
theory and things

www.blackdogonline.com london uk